MW00529469

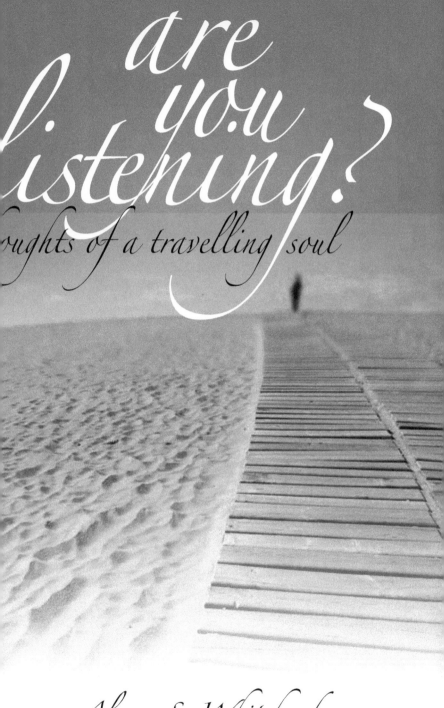

are you
listening?

oughts of a travelling soul

Alonzo S. Whitehead

Thoughts Within..

To Mom's

strong woman, known for strength.
raised two and ten children in her life,
and though it wasn't easy...
she faced the strife.
didn't hang her head none
when no man came;
her babies always ate,
was always proud
of they name.

∞

strong pride, motherly pride...
as she bent, proud...
knees scraping broken-tile floor,
smell from her pots
circling her head/her house...
pride... in knowing hers
would eat.

∞

even the lit'ler ones is bigger now,
and puttin' a strain on her mind...
but time don' slow nobody,
'specially her,
'cuz she knows that you knows
that she's what
you're living for.

1

traveling beauty

i walked by a poem
just the other day…
she positively glowed
as she flowed
right past me…
stunning me into thoughts
that quickly became
just …so…much
white noise…
out of which
i heard birds singing,
heard children laughing;
heard snatches of old R&B songs
from romances past
as I breezed by such
an example of feminine pulchritude,
whose graceful stride…
whose whole countenance…
shouted and defined:
sensuousness!
a poem walked by me
just the other day…
testosterone hormones went awry
as I couldn't even decide
whether to simply laugh out loud…
or just cry…

those eyes...

without Hope,
duinyou know I love
when you say exactly
what you mean
with your eyes.
*

i see myself in them...
content, constantly surprised.
your heart floats in those eyes:
they brim with love
for me...honoring me.
*

there are no grey areas there...
in those eyes.
they don't color things
that the mind attempts
to cover with words.
*

i fell asleep at your feet
dreaming of those eyes...
floating... with sounds of the sea
lapping at my consciousness.
no fear there...in those eyes...
they constantly search;
seeking out the best side
of anything...
the life in those eyes
makes me feel
alive.

El gato negro: The Black Cat

Tribute to Sam Greenlee's Novel: The Spook Who Sat By The Door

chicks said he was one cool cat, that cat.
and the dudes agreed, he was a cat...
agreed he was quiet as a cat:
a saber-toothed tiger.
in a world filled with its' fill
of deceits
this was one 'spook'
who could not...no...would not be beat!
this one wouldn't bow to mere
emotional defeats
this one wouldn't bend to your everyday
racial slurs...
even when they banished him to sub-basement departments...
even when they sent him the cheapest whores...
he remained their 'credit'...their 'shining example'...
daily earning their respect, minute-by-minute sometimes,
yet, at all times rallying for a position
to put his skills to the test.
*

we said "Sir" a lot in the 60's
if it was missing it could cost you your life...
and here was a man who was a gent alright
who used words as skillfully as he used a knife:
a government-trained insurgent
who trained internal outsiders with insider knowledge:
the original terrorist with a tan!
he was the spook who sat behind the door;
to those who didn't know...just The Man.

his fight was not against those 'white'...
his fight was not based on hate...
his fight was for simply what was right;
his fight was for freedom for his race!
it took a heart cold as a Chicago winter,
it took a mind that would make Hannibal proud
he was the original Black Panther
*

he was Black before the Masses,
he was the scream before the Dream...
he was the original scare
who turned the American Dream
into a living nightmare.

4

the tip

without Hope,
duin a service industry
one relies on for salary
what is commonly known as a
gratuity
in recognition of the service performed…
yet… it seems to me
that you are the only one
that doesn't seem to practice this aspect
of your job…at least…when it comes to me!
reasons why escape me, so I can only suspect
it is simply due to your history…

¤

you see…I recall your ancestors tipped
my ancestors over their ships
when they got sick during Middle Passage
crossings against their will:
be it sick from their food…
from their abject misery…
or sick from a state of hopelessness
as Mother Africa receded on the horizon.

¤

they tipped them in tar
if they chose to run too far
from their state of bondage…
capture assured the noose
being tipped over their heads
and tightened around their necks…

¤

(con't)

their sanity was tipped over the edge
as they were forced to witness
the degradation...the abuse... of their women;
forced to endure families torn asunder...
forced even to have their 'manhood' ripped
from them as they were renamed 'boy'...
(con't)
and, wonders of all, they even tipped
the history books in their favor
to reflect those days as ones of glory...
damn...they went back to the beginning...
even the Bible...
held untruths for generations to come
to savor...

¤

now you, today, as a waitress
refuse to show me respect
by withholding the due of a simple tip
yet...you'll not get me to regret...
not get me to feed at the bottom with you...
I'll not even take you to task...
but I will ask you to serve me...
No tip ... but simple service is all I'll ask.

The Key...

without Hope

uesometimes... my thoughts scare me
as they bounce with the force
of a tornado in my mind.
most times ... making sense of them
is rare.
they be as disorderly as spaghetti
with no fork...
while I seek lasagna-like order
over time.

*

sometimes the sidewalk,
grey and pebbled,
silently giggles as I step
on yet another crack...
showing no concern to someone else's
grandmother's back.

*

oftentimes I whistle nonsensical tunes
while cutting my overgrown grass...
while imagining the wail of a million
tortured souls crying out
as I inflict their
gas-powered
death sentence.

*

the heavens unleash a spring torrent,
unexpectantly, while sounds like
"hah...hah" come from a pair of blackbirds
sitting watching in a rotting tree.

*

i hurry from garage to house
and a ladybug seeks refuge in my ear...
surprising me as much as I just surprised
a foraging field mouse.

*

sometimes... there are just those times
when I can laugh along with Life
as it goes along with or without me...
and then there are those times
that I feel that at certain OTHER times
in Life ... I am the Key!

summer madness

he sat amongst us…
a shadthe trees on the postcard
that i'm blessed to call…
my backyard…
shifted in my view today…
as i sipped on my own homemade brew
of the Starbucks variety,
and smoked an a.m. cancerous stick,
i noticed something of a bummer
as i realized the trees in my backyard
had begun to sport a different shade
of summer.

*

they reflect the passage of time
that seems, somehow, to have slipped
my mind
as I trudged through questionable
summer days
that seem for some strange reason to reflect
some other season…

*

they reflect the passing of 'chilltime'…
they underscore my grabbing a jacket
in august…
a thing I don't recall having done in that month
before.
This summer's weather has been tiring…
I mean, it's been downright disarming…
gots' a brother like me walkin' roun' wondrin'
what the hell don' happened to Global Warming!

*

but since each days 'spozed to be a blessing,
and it truly is these days for me…
it's just that I'm of African descent y'see,
and I'm truly missing out on summer's heat.

on the bubble...

whenever i don't feel right...
walk around tense... wound TOO tight...
and get close to letting thoughts
get me, myself, and i into trouble...
then i check my brakes with the quickness
because i can't afford life
on the bubble.
i have to put the stylo-to-papyrus,
pen to paper and sort in verse now,
while my psyche is versatile
and i'm open to feelings that,
at these times, have me reeling.
i then fine-tune my emotions...
my heart straining to hear the pitch,
that perfect note of self which,
after a lifetime of playing the wrong song
at the wrong speed,
is elusive to say the least.
and when I get there I find
it's the bad thoughts that feed
the dead man walking with size 12 feet...
knowing Life is not unlike
a box of CrackerJack's:
the only surprise comes when you look inside...
not as you hide...hide between lies...
hide...between thighs...hide...between highs,
not waiting until seasons change
to take your own version of a sleigh ride
until you become the joke
that fingers are pointed at...
that doors are shown too...
when your 'this' becomes
their 'that'...
and the questions you ask yourself
actually become the answer
forcing you to make haste
in your endeavor
to slide your mind through its'
momentary journey into trouble,
allowing you to escape another visit
with the other side of Life...
on the bubble.

9

missing...

where were you on that day
when the smoke ran like water
and you couldn't see the lighthouse
though the pain of your
self-imposed emotional slaughter?

*

just where were you
when you searched for a thread
across an ocean of despair..
seeking a toehold somewhere
as you, absentmindedly, bit
into a midnight peach
and you blinked,
rubbed your tired eyes,
only to see that you
no longer had to go everywhere…
that you had only to realize
that
you were already there…
hidden behind the sounds
only you could avoid…
missing
amongst the loudness
of your mind's
white noise…

maxed

*lost
in the putrid silence
of your secret hurts…
guilt's bludgeoned onto
your forced, cracked smile…
your pipe a prosthetic
as you take automatic
and fatal puffs,
trying to create a distance
from your Self…
from your Life…
so as not to reflect
on the damage done
when you take $20 puffs
from your trigger-less…
glass…gun.*

little brown / black baby

i held the future in my hands
the other night...
just a little itty/bitty/burnt-butter/colored thang
that Time would mold into a man someday...
too soon.
and, as I held this small wonder
in my hands,
he made me feel as if
i should whisper
powerful words of wisdom
in his ear...
impart future knowledge and strength...
something like:
"little brown/black baby...be Black!"
but I didn't and it gave me a flash of fear
so that I put him down before too long...
and now, in retrospect, I now know
what I should have done all along...
i should have done that 'Roots' thing,
you know, raised him high overhead,
facing stars...
then, I should have brought him in close to me;
close enough to match his tiny lil' heartbeat
with my own...and then whispered powerfully
in them newly-formed ears:
"little brown/black baby...be a song!"
for there's a power in being Black,
and the past is not that long gone;
and if there is but one thing
that we all still marvel at,
then it's the amazing persuasive power
of a Song!
yeah...little brown/black baby...
Be a Song!

Jena Six

(Jena, Louisiana 2007)

"six teenagers jailed on murder charges!"
the headline screamed at me…
reflecting a 2007 African-American reality
of my people, once again, reacting
to a 1950's white American mentality:
a mentality that, once again,
let their actions
laugh
in the face of reparations…
slapped its' collective knee in hilarity
at entitlement…
made that 'raspberry' sound
at their own constitution…
because they thought,
once again,
that there would be no
retribution!

this wasn't 'kids-at-play' in society…
just a mirror reflecting
an administration
that does a daily two-step
at racial reconciliation…
reflecting the reality that history
remains no mystery…
so six Black kids pulled back the sheets
and, once again, exposed
the 'real'…
that this country's problem
ain't across the seas
as long as there exists a
'circle-the-wagons' mentality
when we choose to deal
with America's race relations
reality.

13

Emotional quicksand

when you are wallowing in pain
you don't complain about the rain
that settles over the land around you
as tightly as the emotions you hold
balled inside like a tightly closed fist…

*

you picnic on emotion;
you feast on self-pity…
bar-b-queing your self esteem
until it's a charred version
of it's true state…
munching on a salad of regret, misery, and fear…
you toss around internally,
choking on your own thoughts
that you haven't verbalized yet
stuffed them, pita wrapped, inside…
'cuz this is, after all, a private party.

*

your face reflecting your feelings
as if a 'Do Not Disturb' sign
flashed above your head.
the unexpected arrival of the sun
dissipates,
against your will,
your personal clouds and you
pick up the phone,
acknowledging that you're not alone,
and let a friend know that you hurt…
let them know that your pain
is no picnic.

welcome

everyone has gone…
the fields are empty…
in every memory,
i stand alone…
waiting…
i wait for the tickle
of butterfly wings
to laughingly change
my life…
and sometimes i suffer life's
bee stings as i,
unknowingly,
create strife.
an unexpected smile
stretches into a limousine-long cackle,
as i reach into my bag-o-tricks
and pull sanity out
with tears dripping on my sleeves…
realizing that life changes
in a heartbeat,
and that truth
can frighten.

TENSION

he sat amongst us…
a shatension…
as in pressure,
as in stress.
tension…
as in back pain,
as in sex.
remedies do abound;
although its' every occurrence
boggles one's mind…
and never fails to astound.

*

tension comes early.
tension comes late.
tension requires no timepiece
to show its' unwelcome face.
it comes in the form of a migraine,
but for most, a simple headache.
tension builds in traffic lanes;
it forms in unexpected pains.
it matters not what language you speak,
because tension knows everyone's name.

*

tension laughs at patience,
shreds every desire to attempt
to manage the chaos
it brings to your mentality.
tension seems to relish its' ability
to alter your psychic reality…
forcing you to draw
upon some superhuman ability
to right your Self
and place tension on its' own shelf
as you reclaim your mind…
as you reclaim your world again
until that time
when tension once again
whispers your name.

16

nightmeal

when you stretched out at night...
relaxed...at your horizontal zenith...
had you left plate clean, empty, light...
or was it overflowing and simply
a mess?
*

as you slip into the safety of sleep
does your mind tend to just...neutralize,
or do you roller-coaster into the deep,
roaring into memories sure to
terrorize?
*

are you one to coast, relaxed on thoughts of
harmless fluff, of childhood joys,
of circus tents and clowns,
of past Xmas whoops and birthday party yells
that bring a smile to your face
even in sleep?
*

or is your ride the helter-skelter roaring
past the herky-jerky black-n-white film
of butt-naked whuppins'...accidental pregnancies...
broken limbs...and ambulance sirens
racing...racing...racing
forcing you to squint your eyes closed further
so as not to see the flashing pain...
the well-remembered shame... to not hear
the darkened voices
in the shadows of the night
that always seem to whisper
your name...
*

(con't)

as you look through the porthole
of the past
and pass through its' portal
and choke back the upcoming present
as you glimpse it taking its' meal
greedily...
sloppily feeding on your thoughts
and desires...

*

you blanche...and staunch your
fears
and fight your way back to the
now...
claw your way through...
straining to open your eyes
and earn the right
to stroll once again
among the living...
*

your nightmeal consists not of shortcake and cream,
but of memories that bring forth
screams...
that force you to bolt up straight...
that force you to scream yourself
awake...
forcing you to feed upon the reality that
it is your sanity that is now at stake!
*

as you breath deep in your sleep...
inhaling past memories with each intake,
and find yourself smiling in grandmama's hugs...
sweet-potato pie smells in her hair...
sounds of old big cars and their big-old horns...
of young girls feet tapping concrete as they double-dutch...
you stretch... your eyes open wide...
and you awake.

disconnected

my bad…I cannot reach the world today
for I suffer from a terminal case of …me!
once again, unknowingly, I seem to have
painted my Self into the proverbial corner
so close…so tight…that I had to 'reinvent' myself
just to peek out at… Life!
*
as I realized that all that I had ever believed
to be both True and Honorable about myself
was Nada…Zilch…Nothing…
but self-serving lies.
said realization giving birth
to the undeniable, stunning justification that
someone had taken my Golden Egg
and my Golden Goose was f__king dead!

uncommon snake...

things frequently go wrong
if you're the 'uncommon' sort of snake.
like when your wriggle...tends to wraggle...and
your slither leaves much to be desired...
and your mind kinda' wanders
as you shed your old skin...no focus.

*

normal snakes tend to...get found
by 'normal' little boys playing
on hot, lazy, summer days...
in fields of wheat...in fields of hay.
some get taken home as pets...
they may even get named:
some are named Stanley...
some are named Jake.
but if you're an 'uncommon' snake,
a heavy rock might just be your fate
if you're found sunning
on that same summer day...
in that same field of wheat,
in that same field of hay.

*

like the common snake seeks relief
in the shade of an overhanging rock,
an 'uncommon' snake seeks relief...
seeks shade... from Life...
each time he is introduced to its' 'hard knocks':
no new Nike's for him...nope...
it's recycled hand-me-downs
for his swollen...smelly...feets.

(con't)

20

his bed smelled also...I mean..."PHEW!"...
y'see...it was, after all, recycled too:
old cardboard bottoms and castoff thrift-store insides,
with an old coverlet that used to be Blue!
and his pillows... they positively reeked
from the dirty laundry stuffed inside the cases...
and, because he rarely showered...
his own was a smell
even He couldn't face!

*

and then one bright, summer day
the 'uncommon' snake came out from his shade...
he shed his smelly old snakeskin...
and when he did...wonders...he noticed
that he actually...for a moment...
smelled...quite...new!

*

he flicked his tongue...testing the air
for a trap...
but this was REAL!
So he quickly slithered under a new...
moss-covered...shady rock
before that OLD smell could settle on him,
make him comfortable once again...
before he decided to stay!

*

the next day...as he sunned himself...
napping...dreaming nightmarishly 'normal'
snake dreams...
he heard high-pitched voices...
laughter peels...and he heard:
'Hey, it's Jake!'
and before he could react...
a canvas sack covered him completely.
in the recess of that sack...as the realization hit...
the 'uncommon' snake smiled his first smile
in a long, long while.

i've seen...

through the many worlds
i've scrambled...i've seen.
through the eons spent
enslaved...i've seen.
*
no mo' arm-in-arm skipping
with so-called 'friends'
playing 'rock/paper/scissors'
with their lives:
reaching...seeking...grasping
at a fast-forward reality
with a crooked smile on
a face from a place
where you two-step
with glass idols
in a dance
you call
Life!

dust

No one mixes metaphors quite like I do.
And a well-worn simile fits me like a shoe.
When I open my mouth, you'll get fed some strange things,
I am bald as a jaybird . . . on eagle's wings.

But don't count your chickens before they cross the road.
The prince and the pauper had to kiss a lot of toads.
The bigger they come the easier they go.
I am here to tell you, that's a tough pill to hoe.

I always seem to bite off more than I can handle.
I'm busy as beeswax on both ends of the candle.
When I'm quiet I'm happy as a clam at a bake.
I figure, they can't have it too, so let them eat cake.

A pig in shit always rolls downhill.
Stay out of the deep end where the water runs still.
So, save nine, in time, with a seven-year itch,
Because oil and water . . . and metaphors don't mix.

flawed trophy...

her make a pretty picture her...
sittin' over there...smilin'...
lookin' so much like a 'Kodak' moment.
(even with her somewhat 'ragged' edges)
outstanding thoughts that one has...
should be paid to goddamn think!
but she continually makes my eyebrows rise...
makes them same three hairs...
there...on the back of my neck...slowly rise
when I realize the simple, amazing, fact
that although I've known her
for a bunch o' minutes and a day...
i've never, ever, seen her blink!
*

i think about it...
and you might already have by now...
and I think 'Twilight Zone' thoughts
And all kinds of Wes Craven shit!
I mean, man, she even wears 'extensions'...
Whuzzup! with 'dat!?!
she's a '10' on my scale
both physically and intellectually...
gots potential in every column I check,
but that kind of shit...
(and I think God's with me on this),
kinda' forces a brother to think...
'cuz I for one cain't kick it
with a woman I ain't never, ever,
seen blink!!

last man standing...

we was the crew!
the ones you never seemed
to see separate...or alone.
we always traveled in a group:
bunch o' nappyhead neighborhood
'bay-bay's' kids...
we was definitely
trouble on the way!
*

we was..."'dem boys!"
police knew all our names...
and we pounded our chests at this...
we was proud o' the fact that all we did
was "front-page" shit!
*

we was them
that act before they speak...
we was them
that put other men
six feet deep!
*

then the day came
when I noticed my crew was thinning...
that they was damn near GONE!:
that one disappeared in a bottle...
that one got lost in a pipe...
and dude, shit, his own woman took him out...
and they gots 'money' doing a bid...
heard tell he got 25-to-Life!
not to mention 'shorty'
who left this place
by way of a .45 to the face!
*

that was when I realized,
lookin' 'round da' hood one day,
that it had quietly happened and I'd failed to see
that I was now the last man standing
but by then...I wasn't even me.

25

impact

at the intersection of deep understanding
and mass confusion
the evil one rides in the fast lane
spewing concrete chunks of agony
for those in his wake to wrestle with…
the horns settled in the corners of his mouth
are not to be confused with cherub cheeks
no…by meeting.. apostrophe-like at his mouth
they form the knowing smile telling you
he owns his pain…knows it well… expected from
one
whose only known address is…Hell!
*

he soaks the spice from Life
in straws wrapped in suffering…
in sorrows… letting you believe
you are actually entitled to an opinion…
actually entitled to hope of a better tomorrow…
leaving you with that feeling freely
knowing full well you will not solve the mystery
of your history…of your tomorrows…
without first hitting arthritic knees
and searching the heavens…beseeching…
for in your pain lies your salvation…
not in the tea-bags… not in circus tents
with palms turned up…not in picture-card decks
nor in the mouth of a remote-controlled
televised soothsayer berating his own sins
between commercial breaks pushing spiced dental gum!
no…he waits with a smile as you
wander the aisle in a Safeway
comparing shelves…looking
for the deal of the day.

stranger on a bus...

he sat amongst us...
a shadow...scrunched/hunched into
the farthest of the seats...
into the farthest corner
of that seat.
*

his arms were crossed;
his hands held his elbows.
he resembled no one
that anyone
would want to know.
*

his knees jutted
far out from his seat...
feet tucked, ankles crossed.
tucked tightly into ... himself...
giving away knowledge of him...
simply...that he was a tall man.
*

his eyelids were slits...
almost closed...closed
to the degree that they shielded
and protected the true color
of his eyes from anyone
who might possibly care
to wonder.
*

i averted my own eyes
as i thought....no....felt
he'd caught me
observing him.
*

his lips moved, seemingly, constantly:
they pursed...met and parted
with a frequency that resembled
either quiet prayer or revealed
rampant 'spillover' or unchecked insanity.
(con't)

27

his clothing was of the brand:
'nothing much'…
knees of his slacks
shiny from constant wear.
*

suddenly…the bus jerked to a stop.
front and back doors opening
with that 'flat-tire' sound:
"kssssss…"
*

my head still pointed downward,
which allowed me to see
a pair to too-big brown shoes
passing by.
*

slowly i allowed my vision to rise…
eyes traveling to the rear,
and i saw that the stranger
had gone about his way.
*

a momentary sadness
flitted across my face
as i realized that…because i
had held so protectively to my space
i had missed a possible
Life connection
on a city bus:
a missed human eclipse
that day.

power of a glance...

yeah...
you know me now.
nope...
not my history,
for that remains...to you...
a mystery.
with that one look
that you threw my way
you just met
ME!

*

nope...
not HIM who had
15 addresses in 15 cities
in as many years...
not HIM who hurt HER
with words as sharp as knives...
not HIM who left THEM
before one was even old enough
to say..."Daddy!"
nope...
you didn't meet him
with that one look
(sideways at that)
that one look introduced you to
ME!

*

yes...with that thinnest of looks
you sledge hammered thru all my
well-constructed defenses...
and for that one iota-of-a-second,
that immeasurable amount of Time...
you saw
ME!

*

but I'm safe...thank God!
because YOU knew nothing
of the importance of that one look...
because YOU were blind
to the true power of
a glance!
ahhh...but I also met YOU!!!

29

4:38a.m.

are you one
with "Charmin" memories…
with "squeezibly-soft" thoughts
of your past actions?
or… are you that one
with memories as sharp and painful
as the needlepoint tip of a boning knife
that makes you shout-out in your sleep?

*

waterfalls of soothing thoughts
don't ease your feelings
whose substance eke
like the dark ink of a fountain pen
dripping on a heart
that is lacking
and leaving you
with a look that is at once
slightly skewed
and
strangely questioning…

Time ripple

without Hope,
dudid you miss that moment
when Time ceased to have meaning?
or the minute that expanded...
unexpectantly...
causing you to buckle and stagger
in an inept ballet
that seemed to resemble
your day-to-day
life.

snap judgment!

During this recent resurrection
From my latest soulbender,
I frolicked down broken
Concrete sidewalks ...sideways...
Mouth wide...teeth showing...
At large again, in society,
Feeling quite small.
During my visitation
To the land of devastation
I was scared faithless...sat
Number One
On the short list...
My a life a closed-loop
Of miseryandpain and miseryandpain
Of moreofthesame and moreofthesame.
Enough of this raw deal,
Dealt by the hand attached to me.
Debating time and again... the obvious...
Sorting the mental debris,
Wondering if there be
A different argument to justify
My ghostwalk.
Experiencing moments of recurrent
Virility,
I despair... thinking that it just might take
Nuclear power just to get 'Mz. Soft Legs'
To look my way...
Suddenly sanity is the new option
On sale at my favorite "Safeway"
In the form of a "PayDay" candy bar
Forcing me to walk slowly
On goofy feet,
To the water's edge...
Where I wake up...knocked up...
By a stranger strangely resembling
The choice I had made at 40
That at 50...brought me to my knees:
Arms open...I welcome Me!

brown-eyed girl

my girl has brown doe-eyes.
she has extraordinary, loving eyes.
eyes that make me
mindblind.
they take me to that place
where all is ...whitespace...
and simple pleasure becomes
ALL:
as big and as bright
as a Vegas billboard...
blink...blinking...blinked.
eyes that offer me...sensual delights,
eyes that offer me a glimpse
of Life!
hers are eyes that extend refuge
from everyday struggles.
her are eyes that say 'It's OK!'
to be...me.
her soft, liquid-brown eyes remind me
that i personally want it
no...other...way!
in those eyes ... i lose myself
willingly...nope...i can't resist!
hers are eyes that tease me,
eyes that say...'Hey, please me!'
eyes that promise all will be withstood...
eyes that say, 'with you...I'm all good!'

meet man/that man

meet man/that man
mean man/ some say
him who/ change my life
change my land/ with wave of hand
*

him came/brought pain
life never/be the same
this man/ him who
change my life/ change my land
with wave of hand
*

we scream/him mean
life not/ what it seem
him blind/ cain't see
us mens/ not wantin' him
change life/change land
with wave of hand
*

this man/him sins
change lives/ like bowling pins
maybe man/someday man
us mens'll say/ us not wantin him
change life/ change land
with wave of hand
*

that day come/soon some say
that man/sick man
soon see/ your day

traffic...

strong womadestination unknown
as you left home
with your measly thoughts giving you
your only direction...
you didn't want to face the news
that had put you to the test
the last time you'd used
your own discretion...
you place your feet
squarely
on a ribbon of concrete,
pointed forward to meet a solution...
perhaps a resolution...
that was somewhat better than
defeat
that flashing red light
that only you can see
is but a mental reminder
once again
to not try and compete
with the shuffling of many
slippered feet down the concrete streets
that compose the inner traffic
of your own psyche:
an area whose fabric bears

(con't)

3rd Generation

my girl's grandsons eyes
take me places.
they take me to a future
not yet here.
they take me to my own past:
they bring me face-to-face
with my own ... unspoken fears.
those eyes...one month in his face...
don't even know their true color yet...
they cain't even settle in one place!
*

my lady's grandsons face
is a study in genetic time-travel...
i swear!
i gaze upon his month-old visage
and see reels of African history
cross his brow:
i see Wisdom...unknown strength...
i see Leadership...all nestled in the palm
of my hand.
*

my other half's grandsons hands
have to be seen to be believed:
sculpted...artisan hands...
with an unbroken lifeline
that bears witness that THESE are hands
that will do immortal...creative...things!
*

my woman's youngest daughters son
yawned at me
and a slow-motion smile appeared on his face...
freezing me...weakening me...
unleashing a joy in me so powerful –
I wept!

sleepers

*(on the discovery of foreign London-trained doctors
planning to bomb the U.S. for Al-Qaeda)*

fear is wide awake
and clapping its' hand in joy
while rampantly running
across continents.
this new wave rippling
in a country that slept
when this country was
born.
*

this new wrinkle
of the afterbirth
of nine-eleven
involve imported 'medicos'
whose 'practice' included
the application of pain
to the heart…
and…au contraire to the "Code"…
involved the actual 'taking' of Life!
*

labeled a 'sleeper cell' by those
who are asleep to the whereabouts of…
to the makeup of…to the endgame plans of
those who smile in our face daily.
yet feel we disgrace this planet
by living a way-of-life that is,
simply,
our way of living!
*

i'll not digress into historical rant…
that I save for others in the know…
i just ask that more attention be paid
as I share this new fear we now hold.
excuse me…am I talking too fast,
or are you just listening too slow?

mind tickle......

the tricky thief of Time: sleep…
crept upon me despite
me reaching deep within
for that special alertness
that one finds only at the edges
of extreme physical exhaustion…
this tiny reprieve of energy
confidently held sleep at bay…
left it lying listless
in the jaws of a giant clam…
i pushed my mind forward,
continued my mental mission,
searching the dusty corners of my mind,
searching relentlessly for the someone
that this one calls: me.
memories…like furniture old and dusty
and out-of-place…seemed to race
endlessly past…(like an old cinema flick
on your mama's VCR that has lost its' tracking):
my grandmother's smiling face…
an early birthday party…
me in Halloween outfits at different years…
and me slowly aging to present day.
i shift uncomfortably in my chair,
scratched a head now missing all hair…
and wondered just where
this mental journey would end…
just what would i find…if i found…me?
smiling, i straighten…light a cigarette…
and step into the bathroom to pee…
to hell with it!
i'd try another day to find me…

born in america...

I was born in America.
I was also born black.
I was raised to in America
Raised ... to be black.
yet...I'm told I'm not American...
just hyphenated ...what's up wit' 'dat?
*

I mean, I've spent over the regulation
seven years here...and have achieved...
(how 'dey say it)...citizenship staus...
yet...I'm told I'm not American...
and I cain't handle that!
*

here I stand...me wit' my wide nose,
wit' my broadass fo'haid...and shit...
cain't fuhgit 'dem thick lips...
man...the way that 'chall describes us
it be's no wonder that we's the stuff
'dat nightmares is made of!
*

but whaddabout 'chall...
wit' 'dat strangey-seeweed-like stuff
'dat 'chall calls hair...
and 'dem multicolored eyeballs 'n
'dem small pinched noses 'n tiny lips
'dat combined...makes y'all...y'all.
*

I mean...if you deal with commonalities in race...
you cain't begin to compare...
and if you're supposed to represent
somebody's sweet dreams...
then I'll gladly be anybody's
nightmare!

night flight...

the Time Eaters...the Sleep Stealers...
came again most recently.
those bodacious bastards came,
without being tested
through a front door locked tight...
crept up two flights of stairs
to my cozy little attic lair.
they came without an invite
under cover of night.
(cowards!)
the audacity of these thieves.
and...believe it or not...
they have no feet...
no lips...no eyes...no hands...
no limbs at all that I can see!
yet...they bum-rushed a brother
and, once again, quietly and effortlessly,
made a mess of me.
*

i tossed! i turned!
i cried and cursed!
i kicked at the covers...
i got all wrapped up in my sheets!
i screamed at them... these thieves
who were, once again, stealing my 'Z's'!
knowing, subconsciously, it all to be to no avail...
knowing it could only get worse!
*

then, as suddenly as they came, they left!
allowing me to breathe normally again...
allowing me to maybe even get...some rest.
and that mental whisper informed me
that yet again I'd failed the battle
that occurs nightly when I allow
my own thoughts
to rattle.

him was / now is

him was drunk.
him was...on drugs.
him was...simply put...
'all of the above'.
*

him had no place
to get him mail...
most weekends...
him was usually found
in jail!
*

him was 'sooo' slick...
him was 'THAT' cool...
but behind his back, people said,
'hummph, there go 'dat fool!'
*

him didn't always pass...
most times, he simply failed.
(brother wore two fucking belts
'cause his but was 'dat frail!)
*

him looked far.
him looked wide.
him even looked for him
in her eyes.
*

then one day
him eyes pop wide...
him found him
when him look...inside.

poetic emergency

this poem is beating
itself out of me;
choking me till i find it
difficult to even breathe.
i ignore it...and "BAM!"...
another line comes,
knocking me to my knees!
*

i know not where this poem leads.
i know only that it needs escape.
this is...after all... just a poem, y'see...
i know only that it needs...to breathe.
*

it serves no purpose...this poem...
it doesn't even aim to please.
its' message won't solve world problems;
it definitely won't bring you to your knees.
*

this poem won't bring
any romantic thoughts
to that little head of yours...
nope... this poem can't be written
'cuz this is one o' them poems
that writes 'me'.
*

it refuses, no matter how i try to force,
to " align" , to follow "alliterately"...
no "meshed imagery"...no "onomatopoeia"...
nope...none of that shit!
this poem just screams: "WRITE ME DAMMIT!"
and I'm weak...but a vessel...
so this is it.
*

this poem won't open
new avenues of wonder in your mind.
this poem won't even make her smile
unless I can afford that second bottle of wine.
*

(con't)

42

this poem...this poem's a written 'drive-by'...
a murderous stylistic effort
imparted to you...from me...
this is just one of 'them' poems
that just fucking HAS to be!
*

so...here i've sat pen-in-hand...
held hostage: waiting for this poem
to inspire...
feeling frustration...moments of desperation...
ahhh...how i tire from this
mental masturbation!
*

i know not
where this poem leads.
i know only
that it needs escape from me.
and i 'thank you' for your
patience and understanding
and for allowing this poem
room to breathe.

the journey...

without Hope,
due to psychic theft
of Self,
the one with
Nothing Left
merged his frosty anger
with his spongy...soaked-up
pain
and wondered
as he wandered
if he'd come this way
again...
*

time waits in the shadows
breathing stale, dead air
from the hidden stronghold
of your waking nightmare...
tick...tock...
how can your life
begin anew
if you never even knew
it had stopped...

i thirst...

at times…it's dry inside
this soul.
at times…it's dark inside
this hole.
I reach.
I learn.
I grow.
I yearn.
Knowledge…is water.
I flower within.
seeking restores order.
Faith…quenches my thirst.
I reach.
I learn.
I grow.
I yearn.
daily I drink:
taking just small
sips
from … Life.

Metamorphosis...

if you're walking, toe-tagged,
thru gambling...or just through!
and reality becomes nothing but
a mental fingerprint on your consciousness...
would it behoove you to seek
a new path...
or are you satisfied
walking arm-in-arm
with despair?

*

if your emptiness fills you up
why continue to lift the cup
daily and take self-pitying sips
while wondering why you're just
not...all...there.

*

one look inside
as you kneel on bended-knee
seeking reintroduction to the you
you used to be...

*

reassess...sit...stare
at stars...
grasp at the you
you were before you left!
you didn't go far...so don't look out
to see within
for that's the path that lead you
to the current mess you in...
revamp...regroup...recommit...
one step is all it takes
for you to uncover... for you to discover...
for you to recover.

are you listening?

thoughts of a travelling soul

by

Alonzo S. Whitehead

layout and design
by
Richard Izzard